WEAR THE DAMN *Mask*

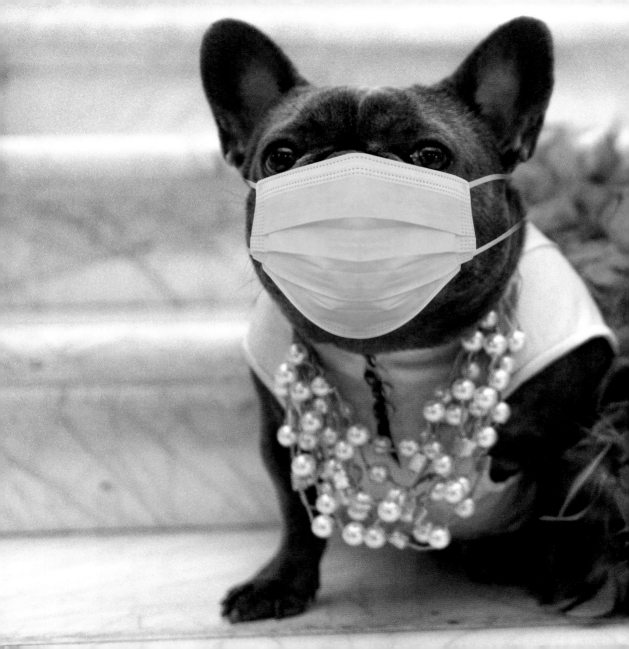

WEAR THE
DAMN *Mask*

IZZY THE FRENCHIE

WITH RICK HENDRIX AND SHANE JORDAN

Gallery Books

LONDON TORONTO NEW YORK SYDNEY NEW DELHI

TO OUR SON, OUR FAMILY, AND FRIENDS.

We love you.

Gallery Books
An Imprint of Simon & Schuster, Inc.
1230 Avenue of the Americas
New York, NY 10020

First Gallery Books hardcover edition November 2020

GALLERY BOOKS and colophon are registered trademarks of Simon & Schuster, Inc.

For information about special discounts for bulk purchases, please contact Simon &
Schuster Special Sales at 1-866-506-1949 or business@simonandschuster.com.

The Simon & Schuster Speakers Bureau can bring authors to your live event. For more
information or to book an event, contact the Simon & Schuster Speakers Bureau
at 1-866-248-3049 or visit our website at www.simonspeakers.com.

Interior design by Jaime Putorti

Manufactured in the United States of America

1 3 5 7 9 10 8 6 4 2

Library of Congress Control Number: 2020943598

ISBN 978-1-9821-7122-3
ISBN 978-1-9821-7123-0 (ebook)

WEAR THE DAMN *Mask*

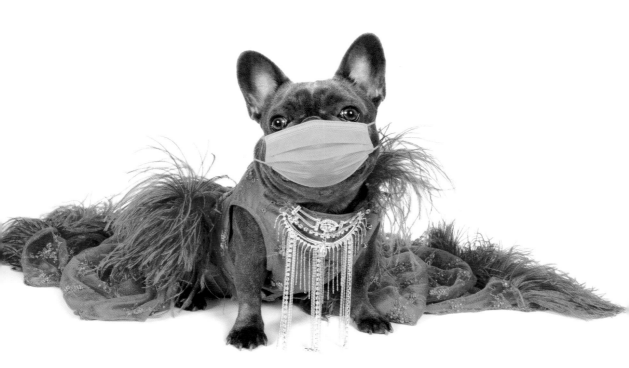

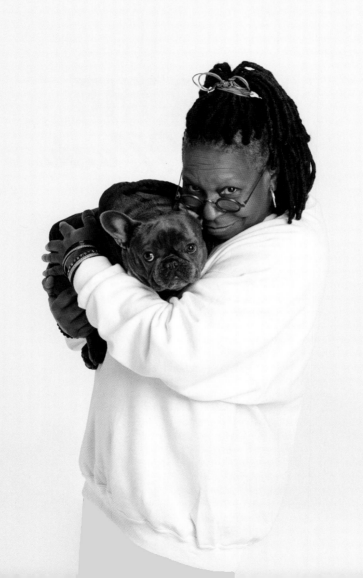

~ INTRODUCTION ~

Izzy is my granddog-in-law, married to my granddog, Fil. She's a four-legged activist who wants us all to get our act together because if we don't, it means that none of Izzy's friends can come outside to hang and play or sniff a new friend's butt. Everyone should pick up Izzy's book . . . You know what happens when these bitches can't get outside.

Whoopi Goldberg

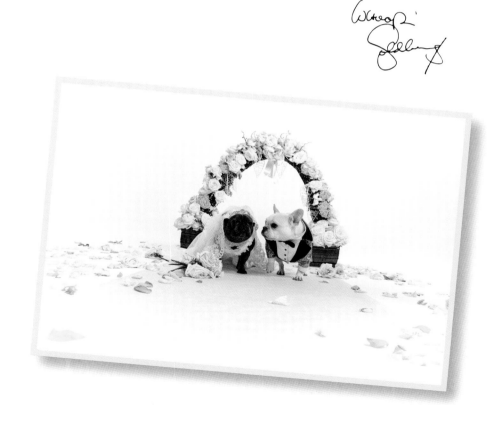

This book is an instruction manual for all the Karens in the world who don't know when to . . . wear their damn mask! And when not to! So I figured that I'd help you out with a straightforward, easy-to-follow guide you can reference every time you leave the house.

Turn the page to find out when you should wear the damn mask!

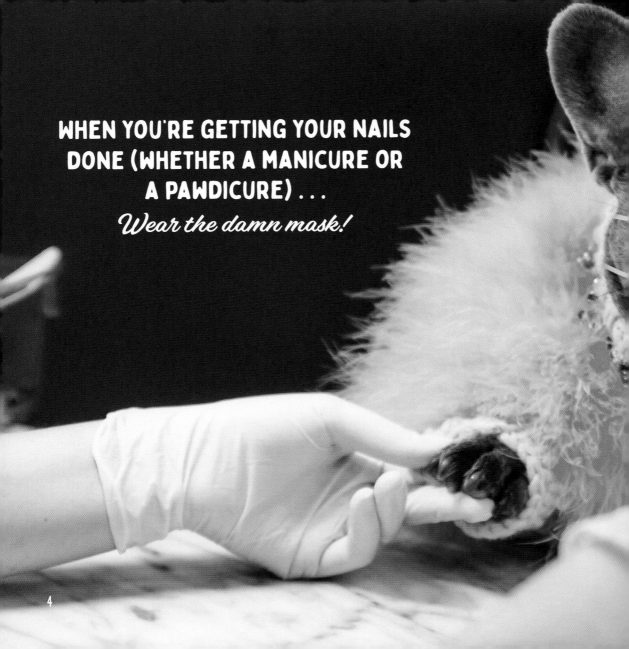

WHEN YOU'RE GETTING YOUR NAILS DONE (WHETHER A MANICURE OR A PAWDICURE) . . .

Wear the damn mask!

4

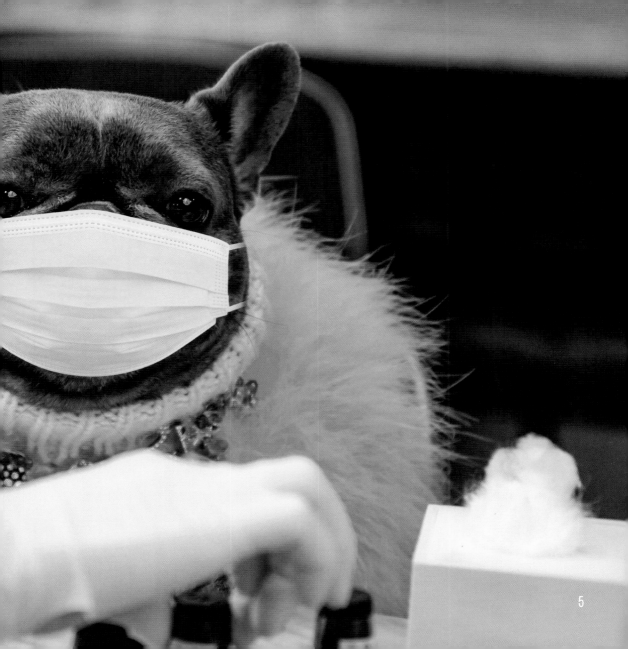

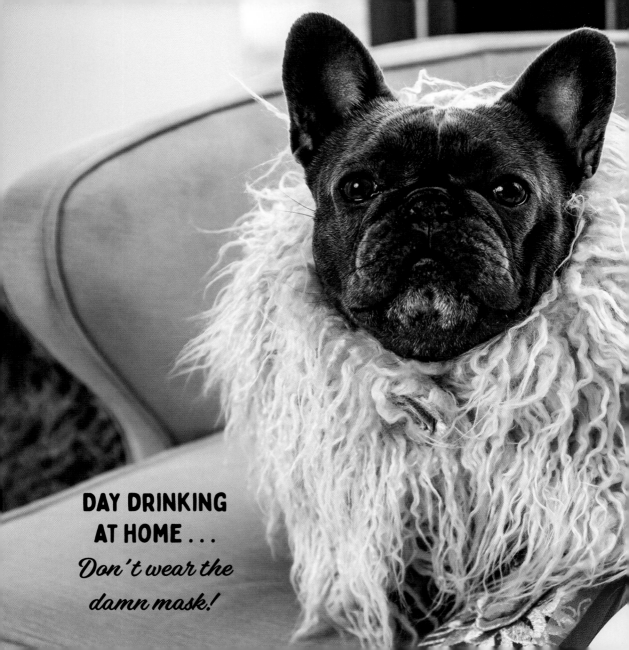

DAY DRINKING
AT HOME . . .
*Don't wear the
damn mask!*

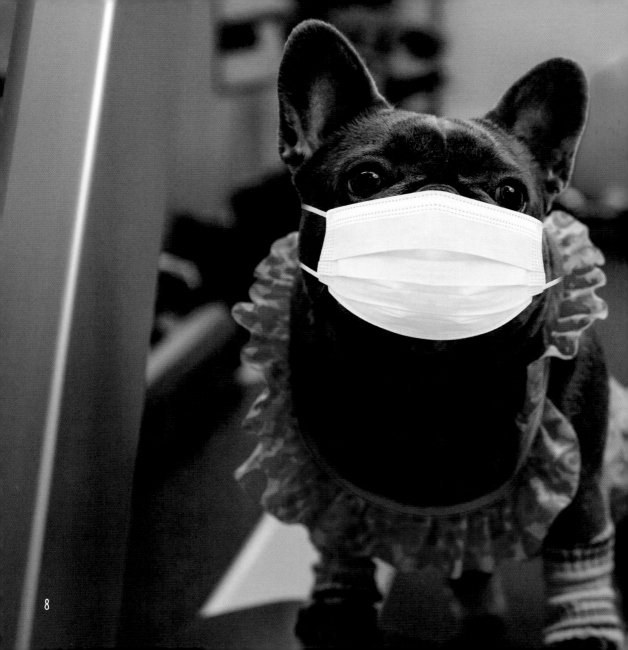

AFTER YOU FINISH DAY DRINKING AND WANT TO WORK OFF ALL THOSE COCKTAILS IN THE GYM . . .

Wear the damn mask!

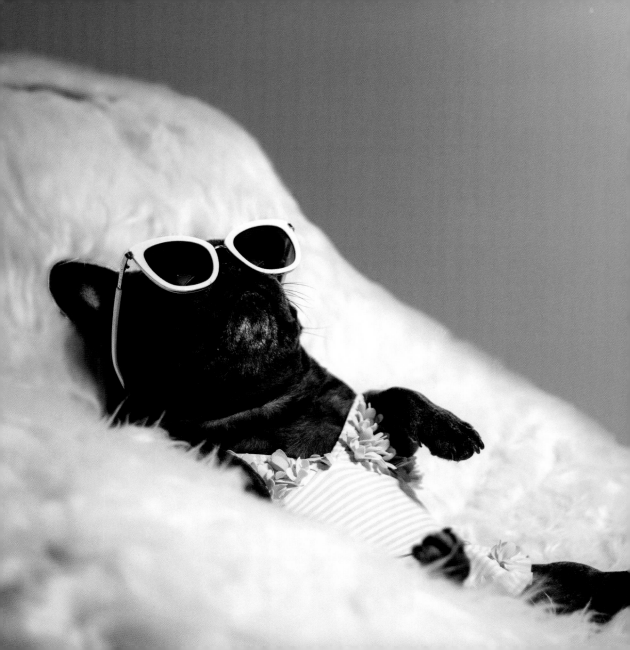

WHEN YOU'RE SUNBATHING AT HOME . . .

Don't wear the damn mask!

But be sure to wear your dang sunscreen.

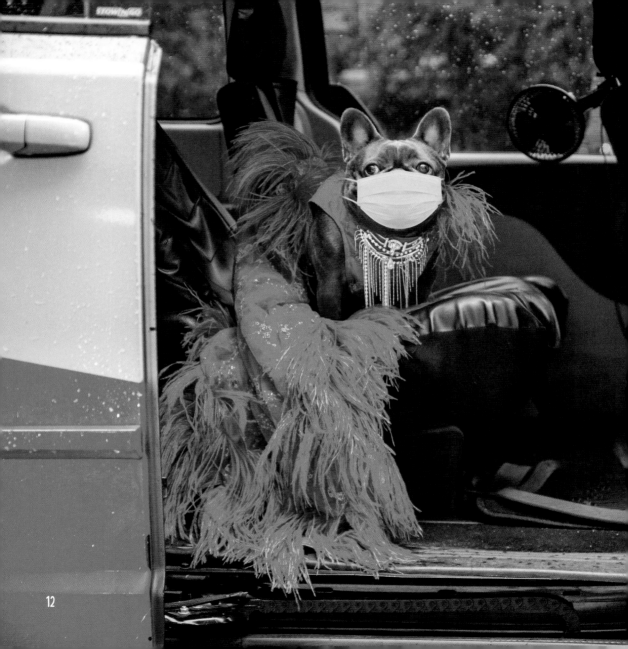

TAKING A TAXI TO THE COVID RELIEF MUTT STRUT . . .

Wear the damn mask!

DRIVING IN YOUR OWN CAR TO GIVE AWAY HOMEMADE BANANA BREAD...

Don't wear the damn mask!

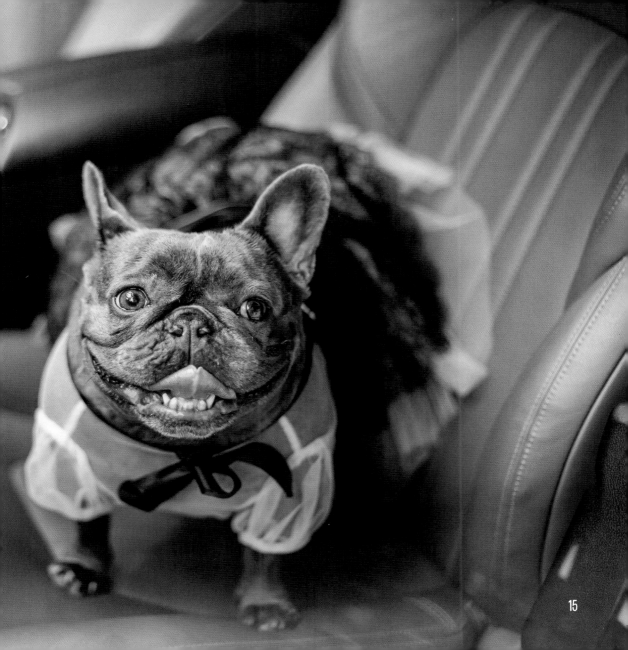

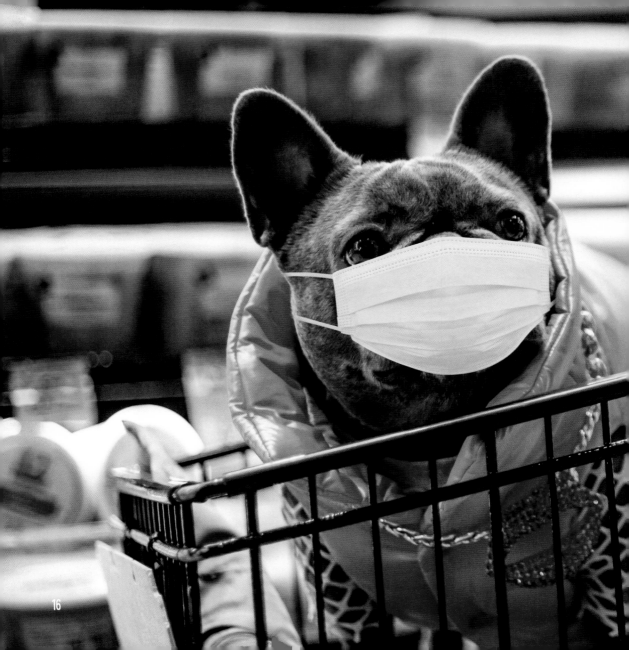

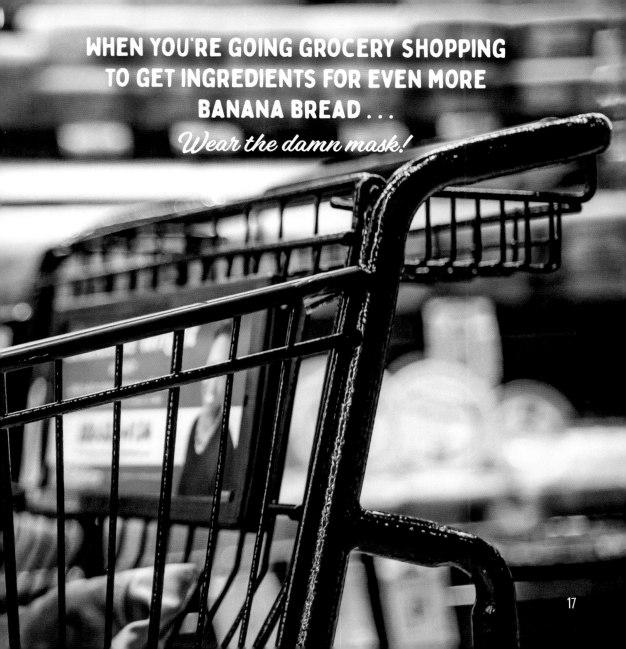

WHEN YOU'RE GOING GROCERY SHOPPING
TO GET INGREDIENTS FOR EVEN MORE
BANANA BREAD...

Wear the damn mask!

WHEN ORDERING TAKEOUT . . .

Don't wear the damn mask!

IF YOU TRY TO EAT YOUR
DINNER WHILE WEARING A
MASK, THEN YOU PROBABLY
NEED MORE INSTRUCTIONS
THAN THIS BOOK OFFERS.

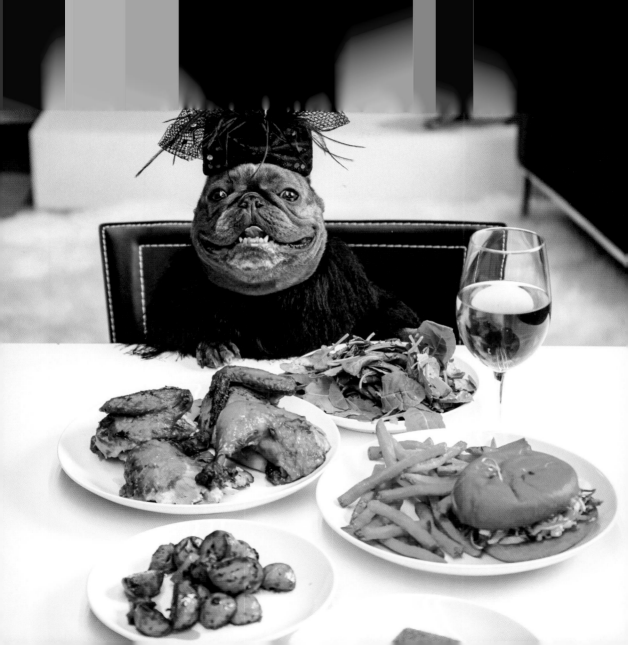

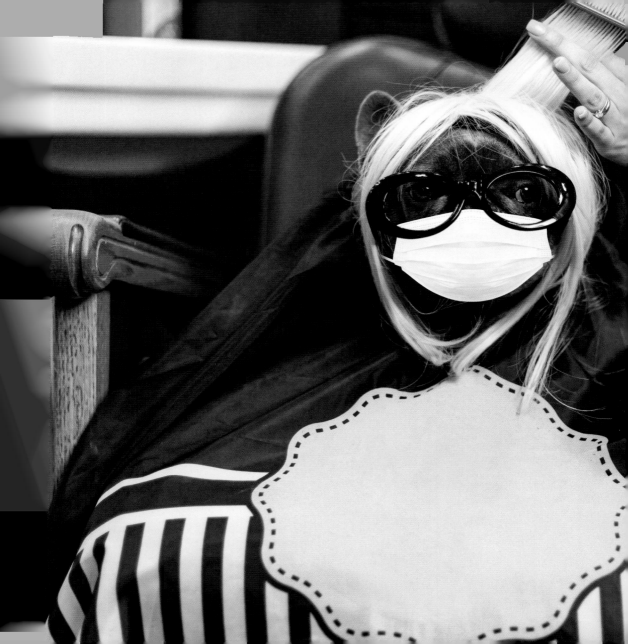

WHEN YOU'RE GETTING YOUR HAIR DONE AFTER MONTHS OF HAVING TO DO IT YOURSELF . . .

Wear the damn mask!

WHEN YOU ATTEND
A VIRTUAL PARTY . . .

Don't wear the damn mask!
But bring lots of snacks.

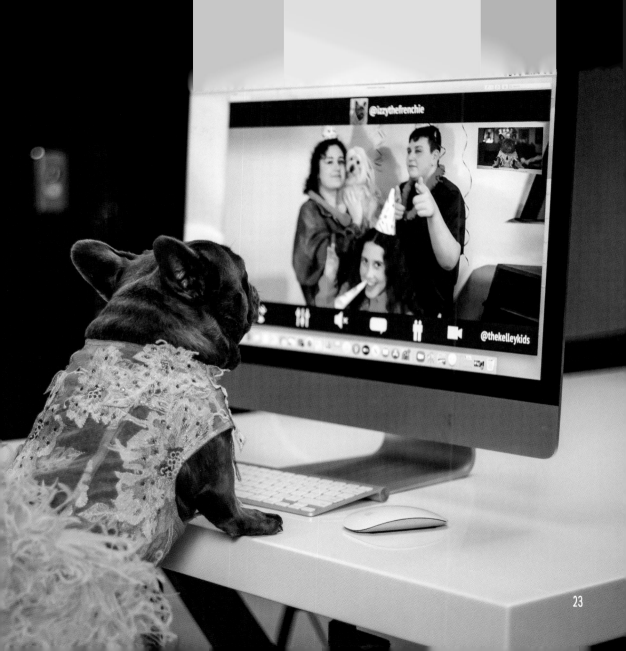

@lizzythefrenchie

@thekelleykids

23

WHAT HAPPENS IF YOU
DON'T WEAR YOUR
DAMN MASK WHEN YOU
SHOULD?

Take note, Karens!

IF YOU LEAVE YOUR
MASK AT HOME AND
IGNORE THOSE SOCIAL
DISTANCING GUIDELINES,
YOU MAY NOT BE ABLE
TO SEE ANYONE FOR A
WHILE!

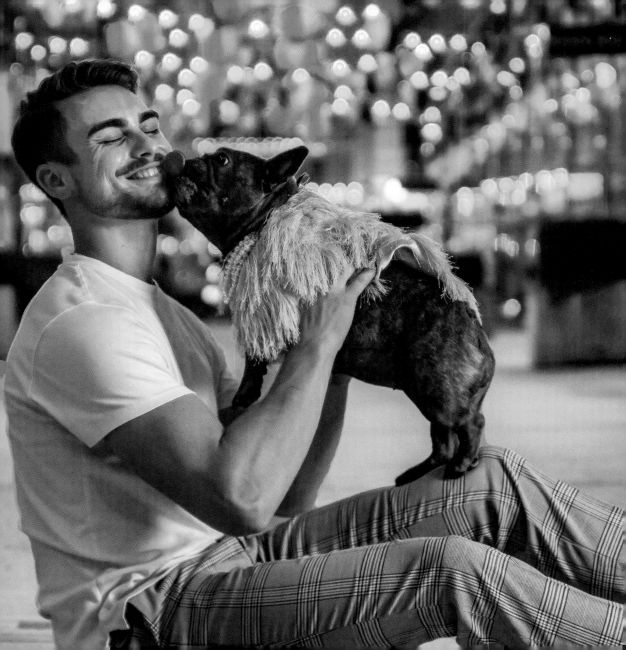

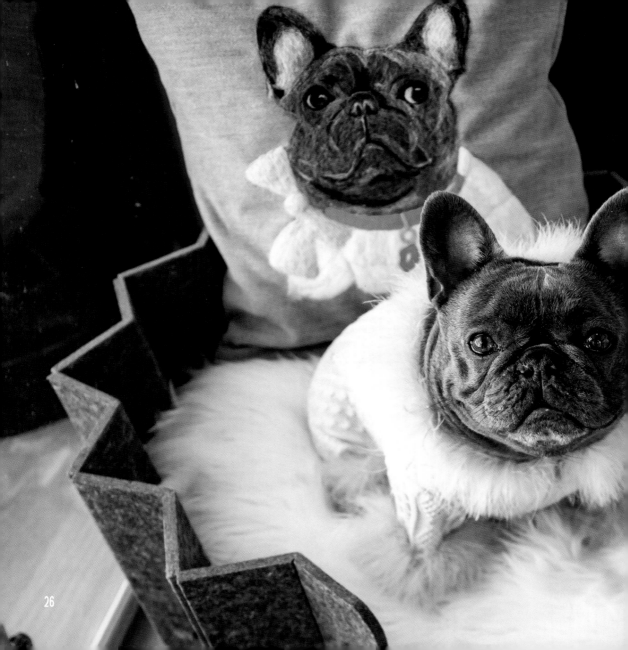

YOU'LL HAVE TO QUARANTINE
FOR DAYS . . .

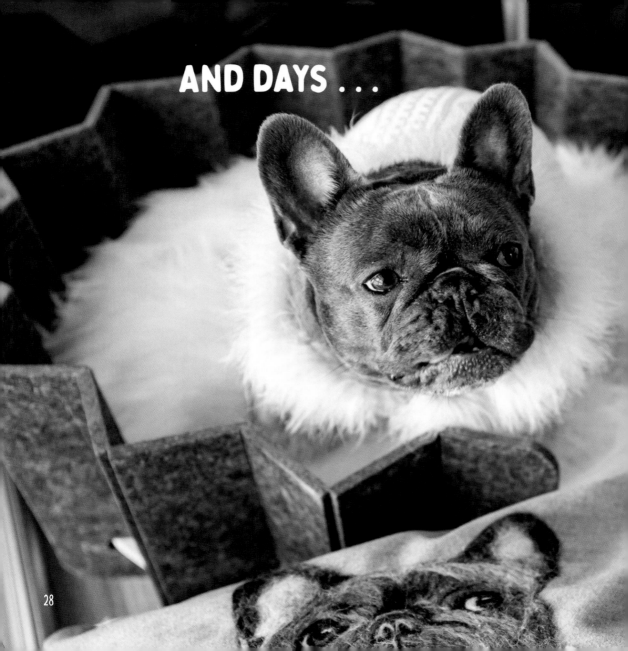

AND DAYS . . .

AND DAYS!!!

SO.
MANY.
DAYS.

31

UNTIL FINALLY . . .

YOU GET TO SEE YOUR FAMILY
AND FRIENDS AGAIN.

BUT ALL OF THAT TIME IN ISOLATION COULD
HAVE BEEN AVOIDED IF YOU'D JUST
worn the damn mask!

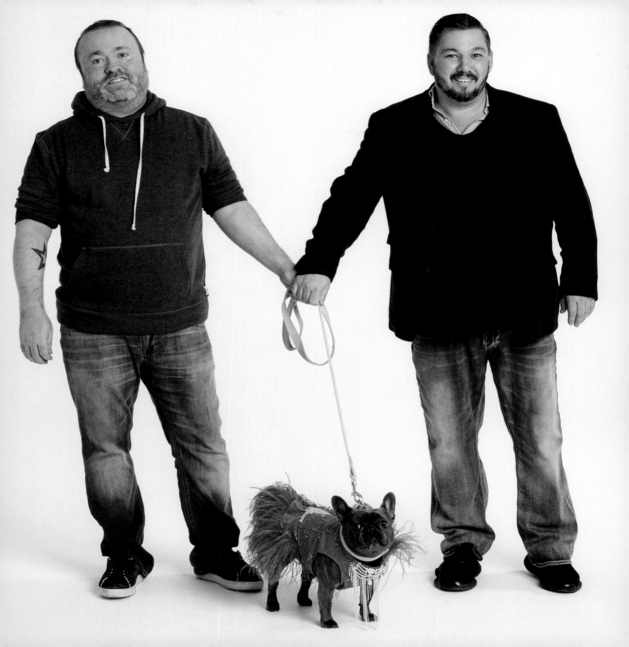

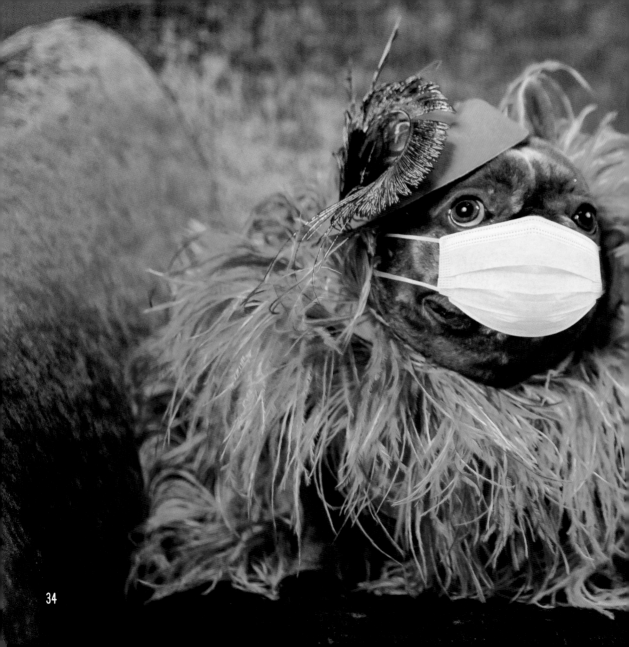

SO, TO ALL YOU KARENS
AND NEVER-MASKERS,
THIS IS A NO-BRAINER.

35

KEEP YOURSELF AND THOSE YOU LOVE SAFE, USE YOUR BRAIN, AND REFERENCE THE GUIDELINES IN MY BOOK TO KNOW WHEN TO . . . *Wear the Damn Mask!*

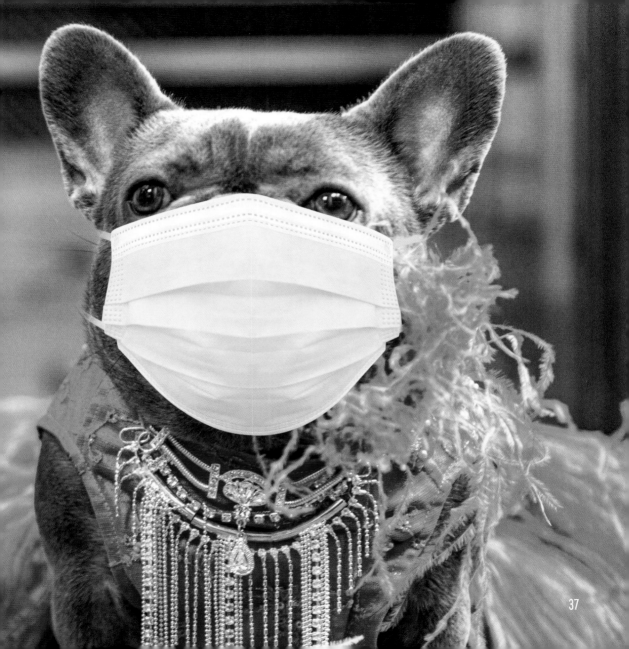

❧ ABOUT IZZY THE FRENCHIE ❧

Izzy the Frenchie, named "The Joan Rivers of the Pet Influencer Community" by *Vogue* and *Paper* magazine, has been featured by TMZ and in AP News, *Vanity Fair France*, the *Daily Mail*, *People*, and other publications. Her "wedding" to Whoopi Goldberg's granddog, Fil, received extensive coverage from Brides.com and was named "2019's Wedding of the Year" by *Entertainment Tonight* and "Cutest Dog Wedding Ever" by *The View.* She was a 2020 Webby Award Honoree and August 26, 2020, was proclaimed Izzy the Frenchie Day by the mayor of Nashville, TN, in her honor.

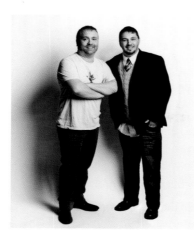

⤳ ABOUT IZZY'S PET-PARENTS ⤳
(AND COAUTHORS)
RICK HENDRIX AND SHANE JORDAN

Dr. Rick Hendrix was born and raised in the Appalachian Mountains of North Carolina. Shane Jordan was raised in Dallas, Texas. Hendrix and Jordan ran a music marketing firm for more than two decades, helping score hundreds of number one songs and more than 250 million-selling albums for artists like Whitney Houston, U2, Garth Brooks, Miley Cyrus, Mariah Carey, and others. The duo worked on the soundtracks to the hit films *The Passion of the Christ* (Mel Gibson), *The Prince of Egypt*, and *Hannah Montana: The Movie*. Jordan is a civil and human rights contributor to *The Advocate* and *HuffPost*. Hendrix received a doctorate in sacred music and theology, and later studied at Oxford while advising several US presidents and politicians on faith and religion. The duo both held seats on the Hillary Clinton 2016 Presidential National Finance Committee.

⌐ ACKNOWLEDGMENTS ⌐

No words can begin to convey our heartfelt gratitude to the best agent in the world, Jessica Watterson. You have truly been the dream agent and friend an author could ever imagine. You were always uplifting, supporting, and encouraging along the journey. Your work ethic was tireless in your pursuit to get our book read.

Thank you to Molly Gregory for believing in us and for seeing our vision make it to print; thank you for the fantastic ideas and edits. You made this such a fun project. To you and the amazing team at Gallery and Simon & Schuster, we thank you for the hard push to get this book into the right hands at a trying time. A time when we all could use a smile and a little reminder. You guided us through the most amazing photo shoots and edits in such a short period.

To Whoopi Goldberg and Alex Martin Dean, we tear up writing this. You are our family, and we miss every second in life we do not get to spend with you. We cherish the memories and laughs. We can't say enough about the Christmas when Fil was running around the house. You told us to get a Frenchie. We were a bit heartbroken from the loss of our other dog. And thanks to you both, this special little girl named Izzy came into our lives. And now that our fur babies are married, you are stuck with us for good. We love you!

To Tom Leonardis, we love you more than words can say. You have lent an ear and a shoulder many times in life. You always have a vision, and you always have a plan bigger than we can imagine. Thank you for putting together a wedding that brought an avalanche of press for Izzy. You genuinely amaze us.

To celebrity pet stylist Lola Teigland, you never cease to amaze us with the unmatched fashions you design. You keep Izzy looking stunning. Thank you for your friendship.

To *Paper* magazine and Eliza Weinreb, thanks for giving Izzy her first big media feature in your iconic "Break the Internet" issue! WOW!!! What a starting point you created for Izzy!

To Karina Deaver, Elsa, and Jude, who along with Izzy make up our fun, amazing blog, *Pawshion Police*.

To Stephanie Kelley, for not only being such an amazing lifelong friend but also helping us frame so many of our crazy ideas.

And last but CERTAINLY not least, to our little diva Izzy: Thank you for making us smile EVERY SINGLE DAY!

PHOTO CREDITS